Mas Creatures

Carlos Huante

designstudio PRESS

Psalm 86, verse 8

There is none like thee, O Lord my God;
neither are there any works like thy works.

http://www.carloshuanteart.com

Art Direction: Carlos Huante

Published by Design Studio Press
8577 Higuera Street
Culver City, CA 90232

http://www.designstudiopress.com
E-mail: info@designstudiopress.com

Printed in China

Hardcover ISBN 1-933492-06-6
Paperback ISBN 1-933492-07-4
Library of Congress Control
Number: 2005928044

10 9 8 7 6 5 4 3 2

Thank you, Monica, for all your love and support. You are the best....

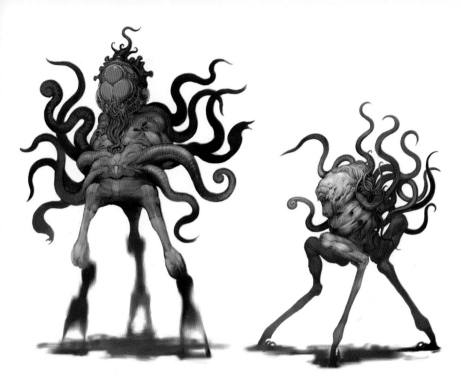

In order to design a character properly you have to know a little about it. I approach this by creating a synopsis or a vignette for my characters to dwell in. That way I know what the motivation of my character is. If you are designing for a film with an existing story, you have a canvas from which you can riff. If the story is a good one, then creating the characters can be a good time. A good designer always dabbles with storytelling. I mean, you don't have to be an accomplished writer but if you think about more than just the aesthetics of your designs, and actually think about their personalities and their back-story, your creativity will grow.

So, here is an example of what I mean by creating a synopsis:

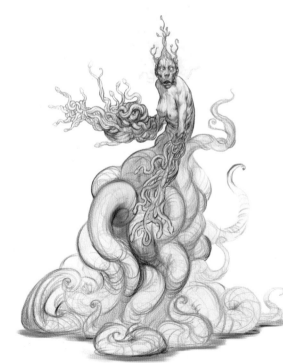

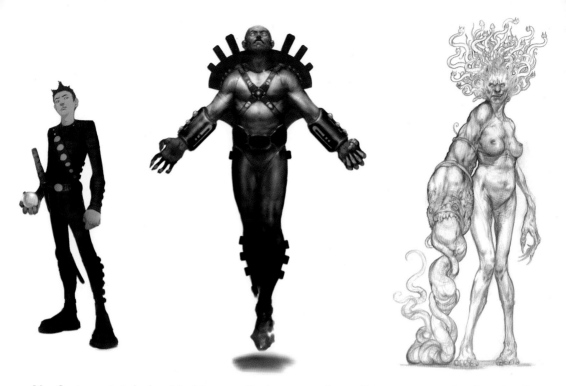

Mas Creaturas started when I had to name the two designs on the top of page 4. With all the tentacles, they reminded me of a Cthulu or Medusa, which started me thinking, "Medusa is a Gorgon and what does that mean? Does that mean there were others like her or was that just the race of people she was from before she was turned into a monster?" I'm not well read on the history of the people in the folklore from which she came, before she was cursed. For my purposes, and to simplify things, I interpreted that she, as the monster, was a Gorgon. I then thought, "What if Medusa could somehow create her own kind?" That would be interesting. Medusa has her own Gorgons. I called them Medusa's Gorgons. Then my thoughts went to, "What if Hera was a disease, a virus or a fatal agent instead of the goddess? And what if a new character created this Hera?" So I created Koleksis. He's the creator of the Hera virus. Medusa was his conduit through which he could have ultimate power, but Medusa's will proved to be too strong for even Koleksis' control. My thoughts

moved on to Perseus as a young boy from the village, who, with a little help from Hercules, was sent out to take care of Medusa. I figured on Perseus being the chosen one and possibly possessing some special gift that would allow him, alone, to be able to see Medusa without being turned into stone. Hercules would be there as he was in "Jason and the Argonauts." So there it is, a very rough synopsis that gave me enough information to start drawing the characters.

You'll notice the changes that the Medusa character goes through. After I scanned the drawing for Medusa and compared it to the rest of the characters, I thought she seemed less impressive, so I tried increasing the amount of tentacles. For some reason, it still felt flat. So at the last minute, before I turned in the artwork for this book, I decided to try a different approach, which I thought worked better than the first.

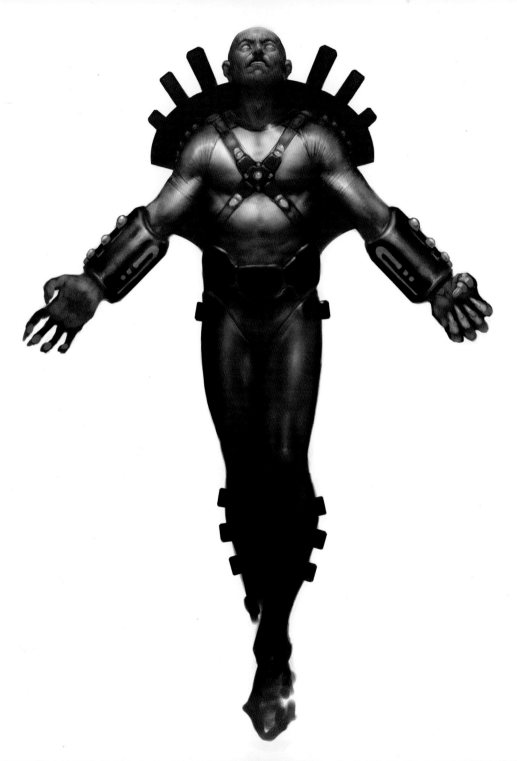

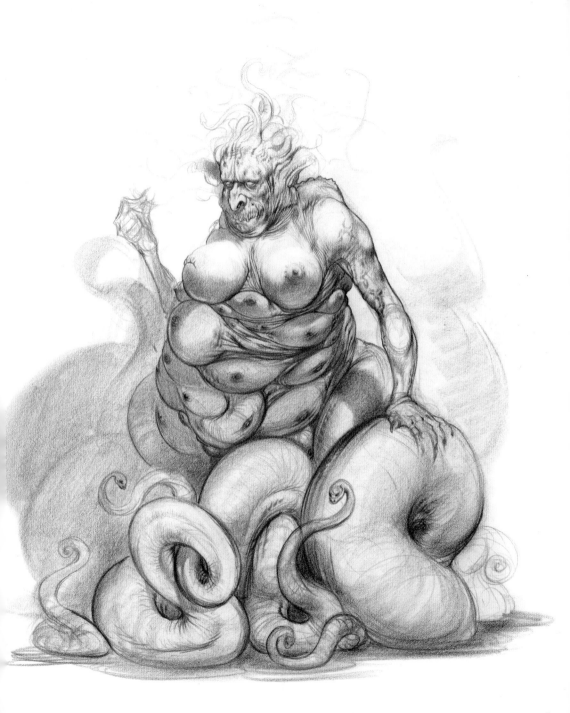

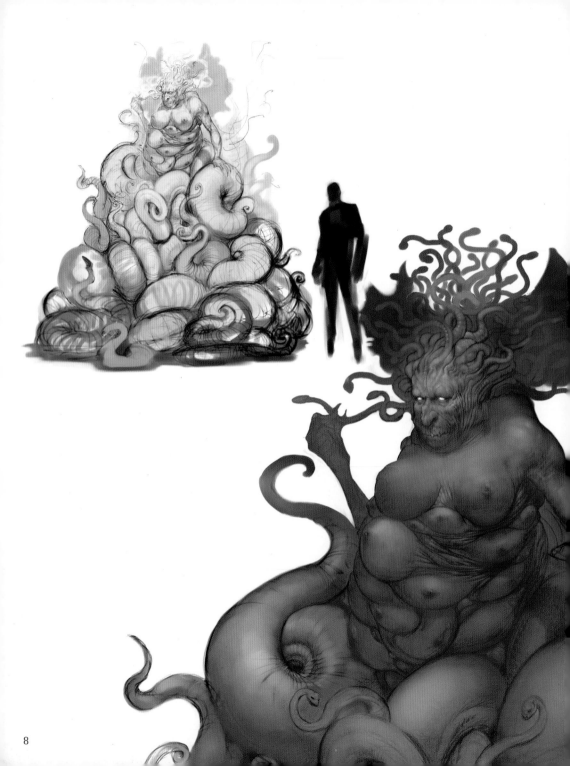

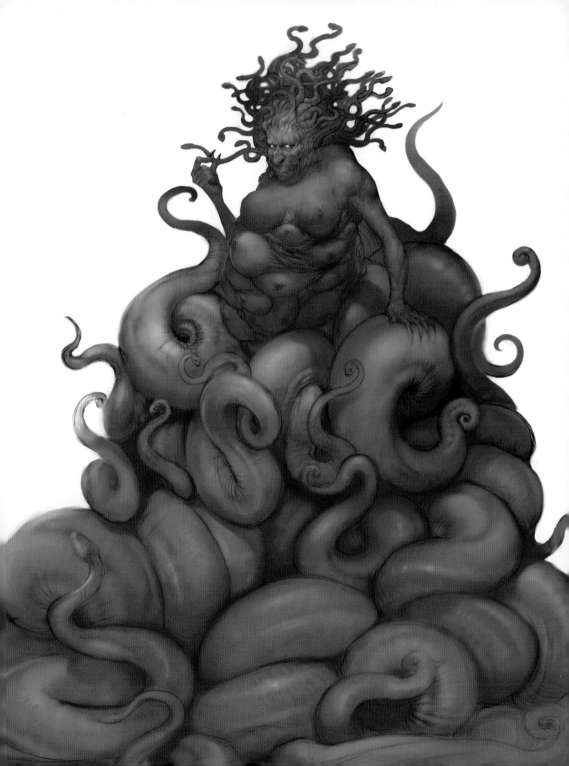

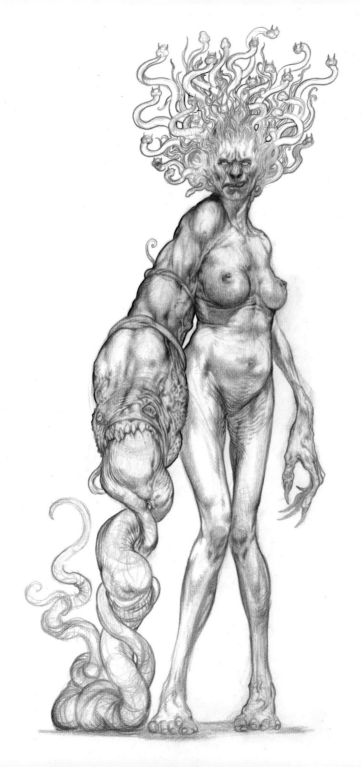

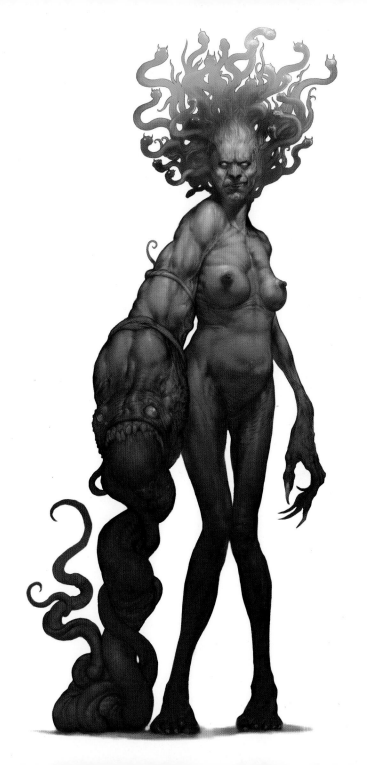

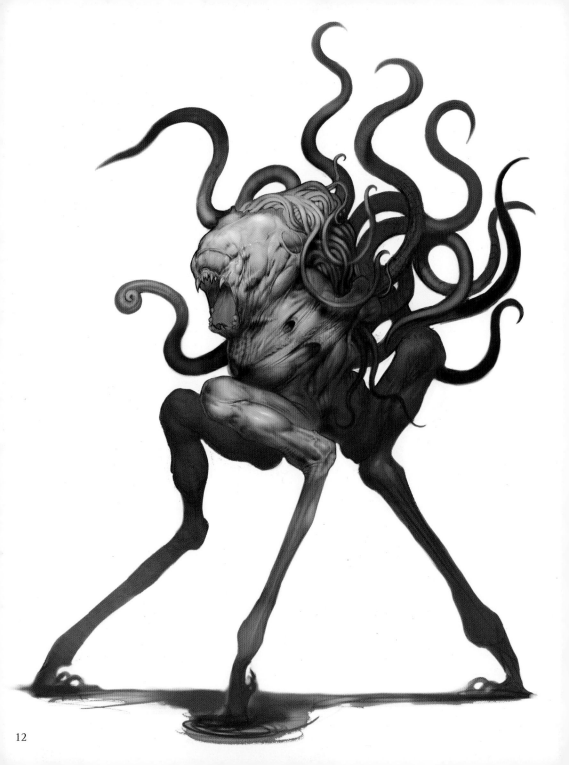

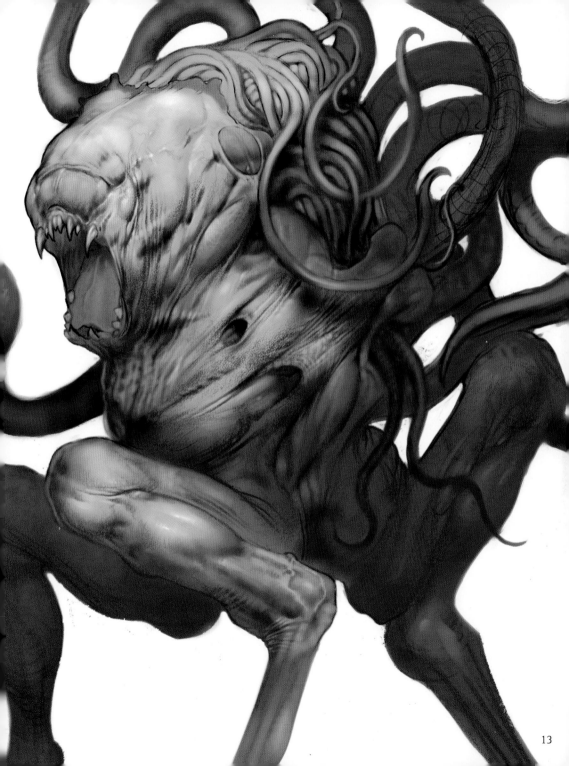

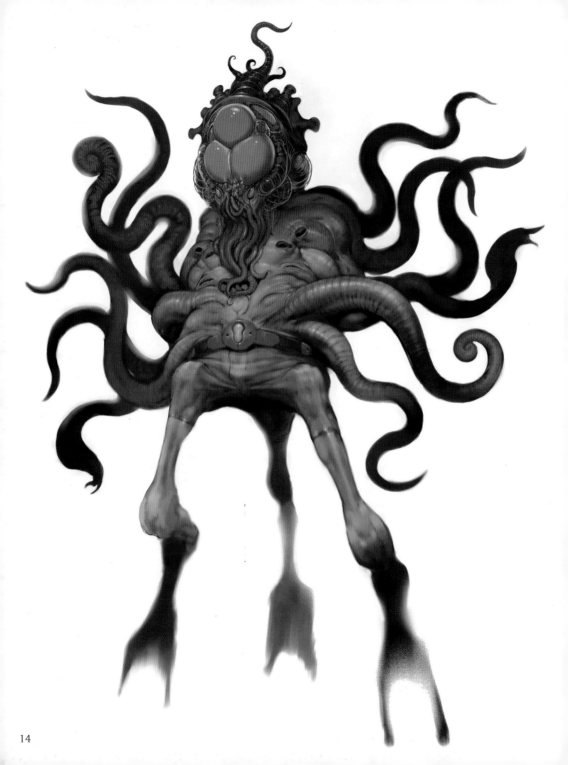

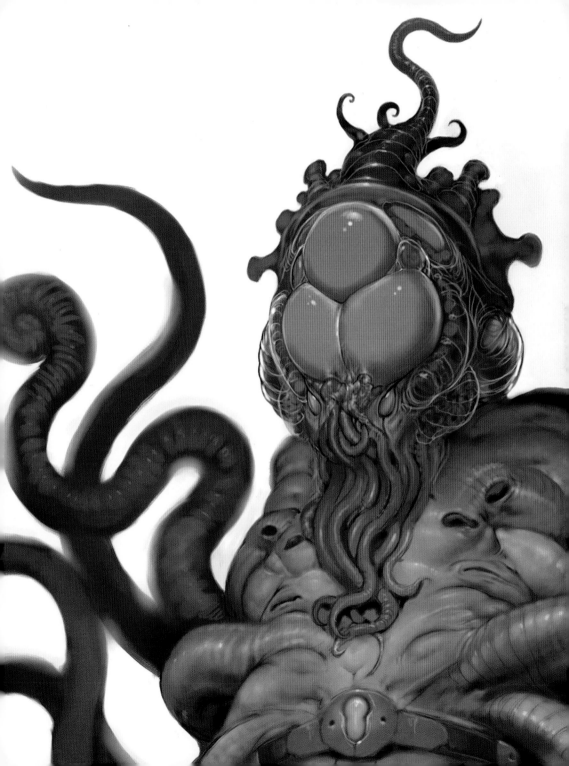

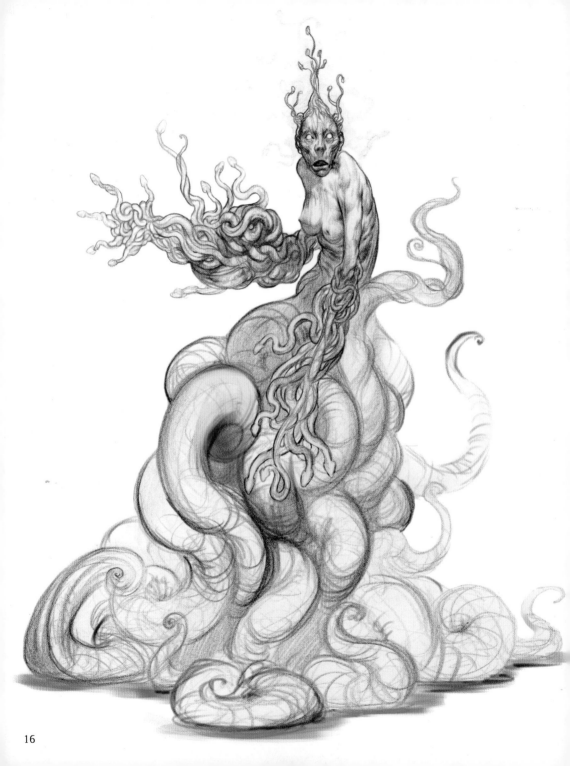

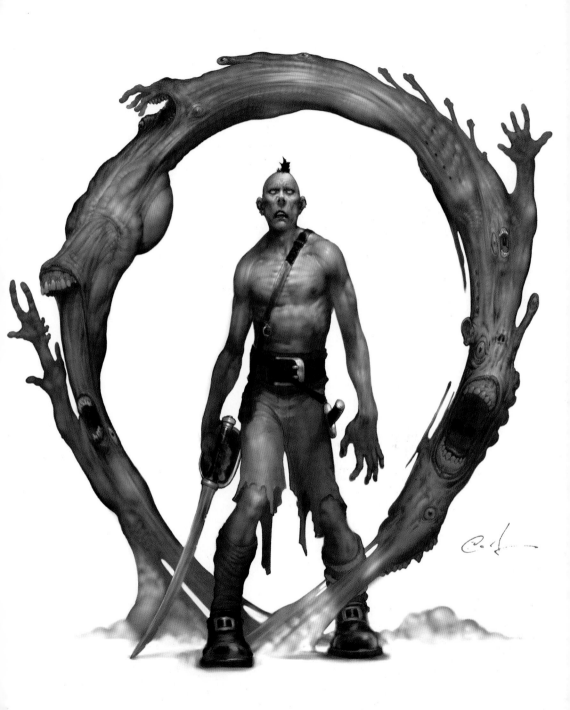

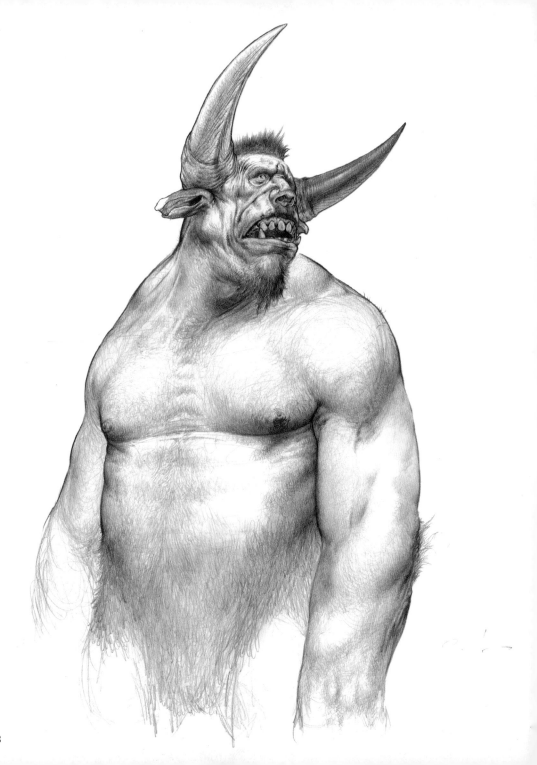

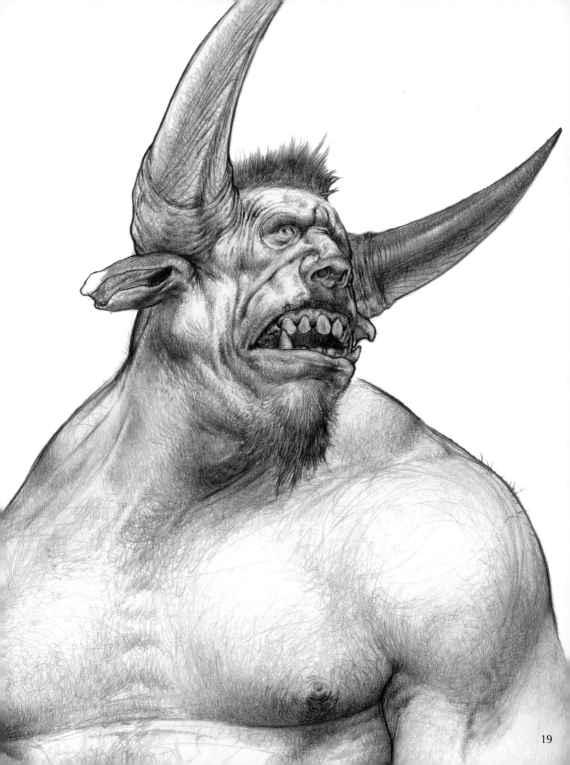

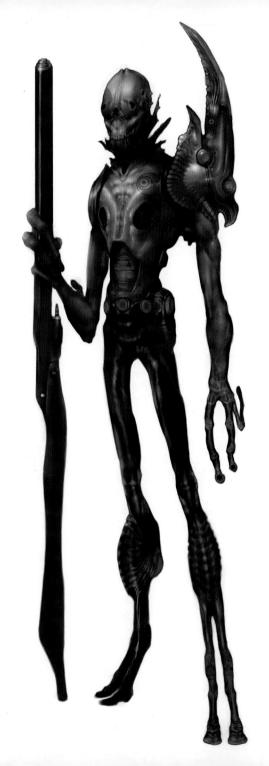

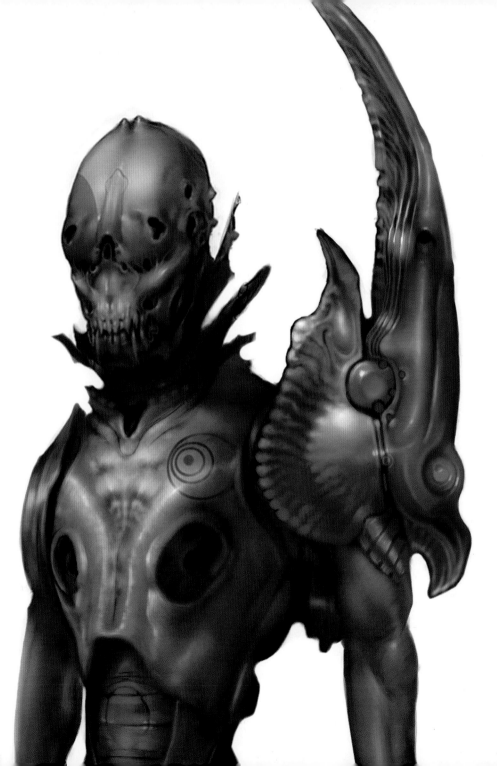

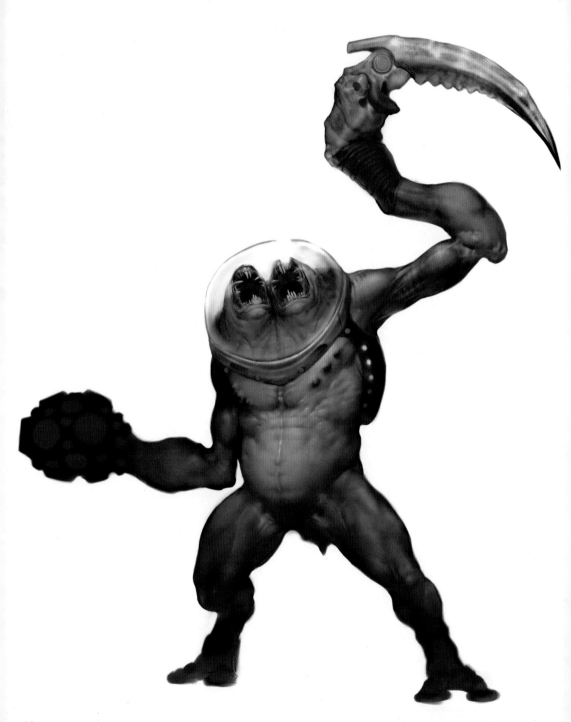

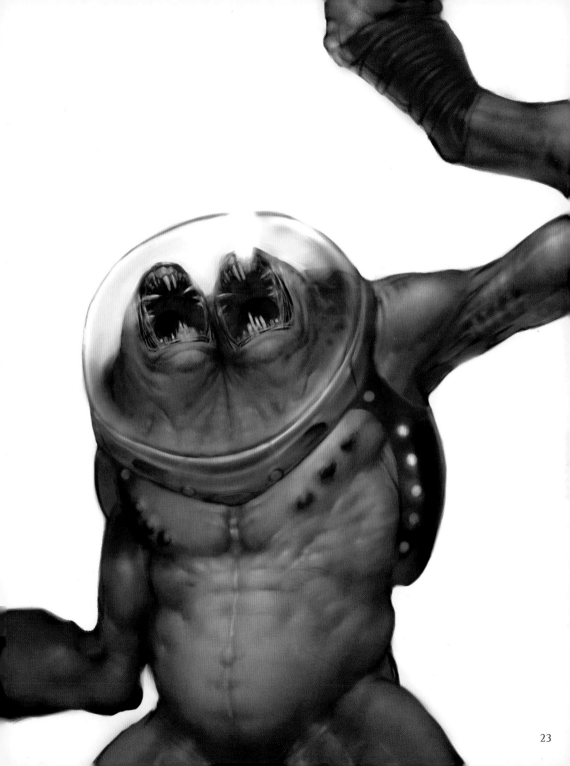

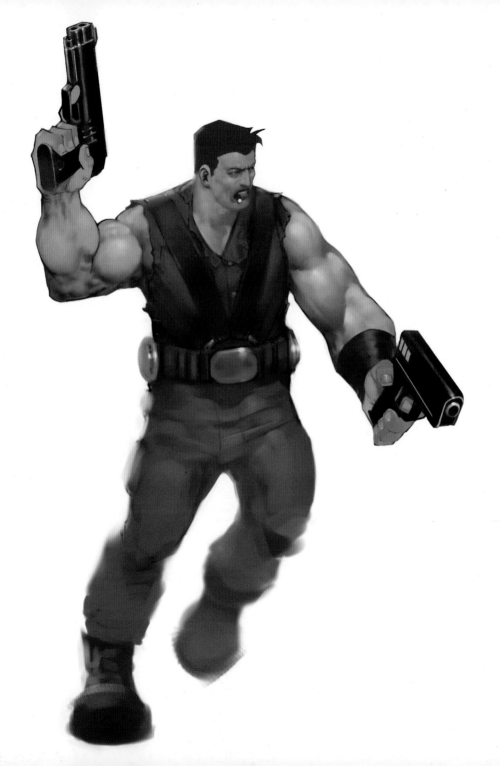

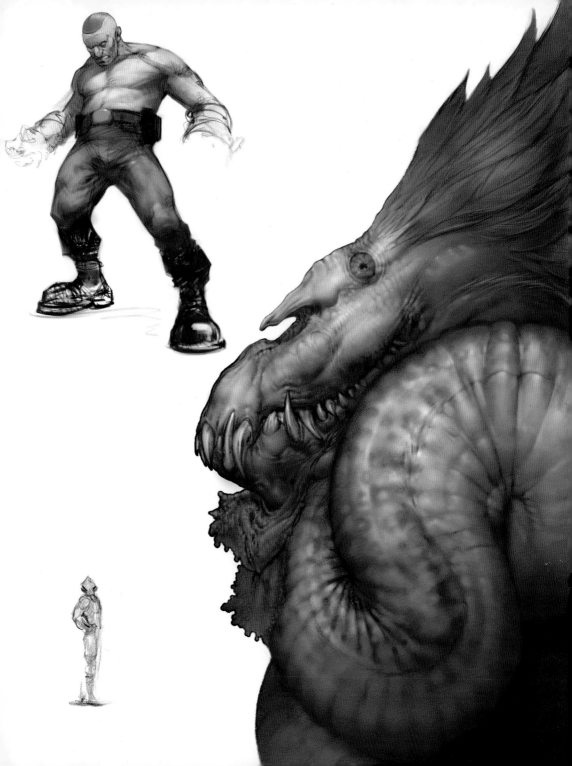

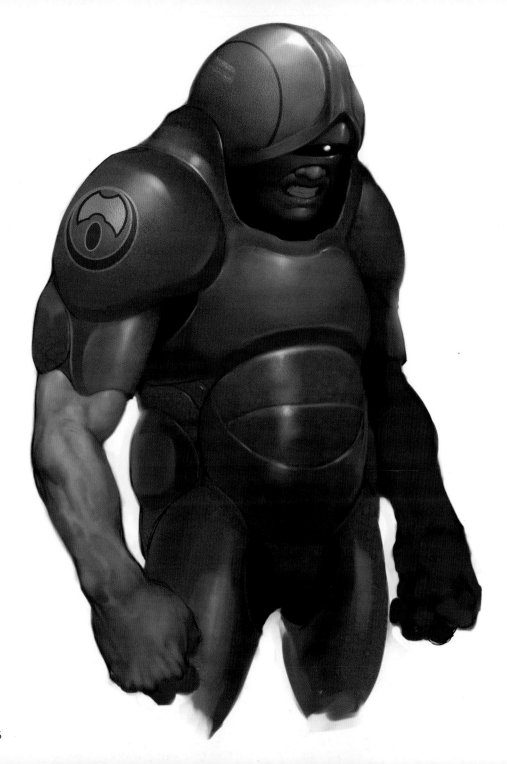

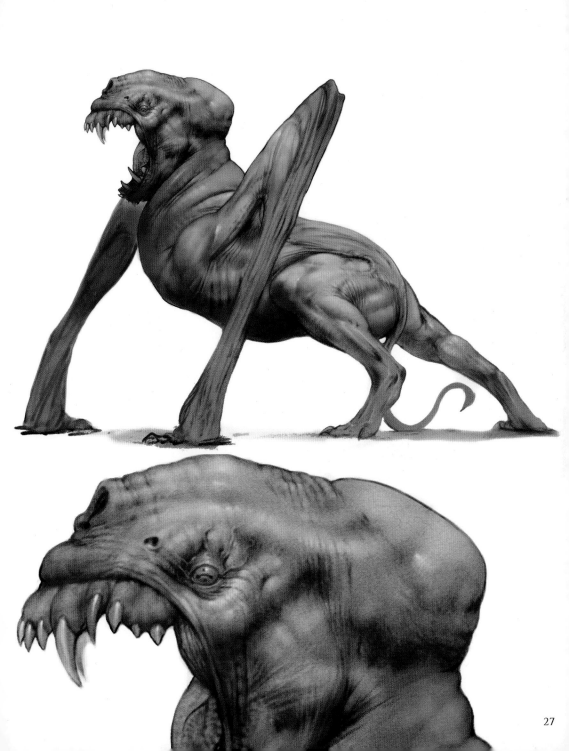

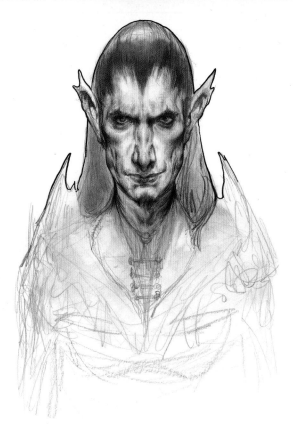

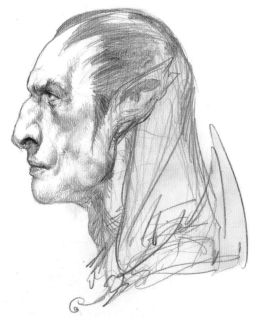

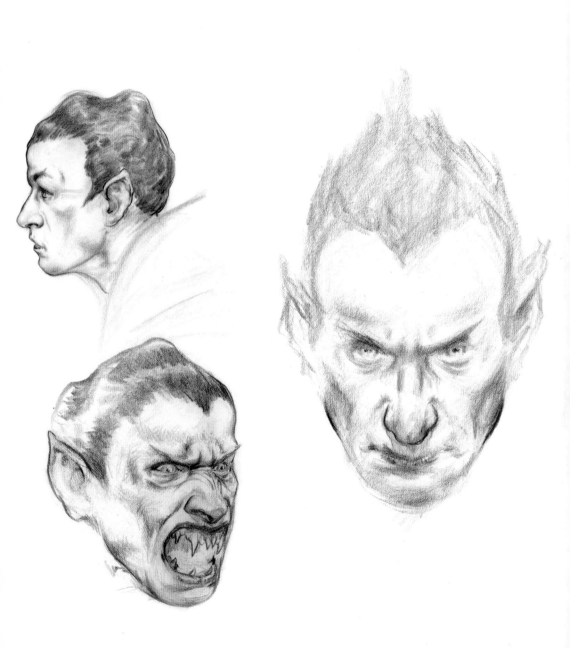

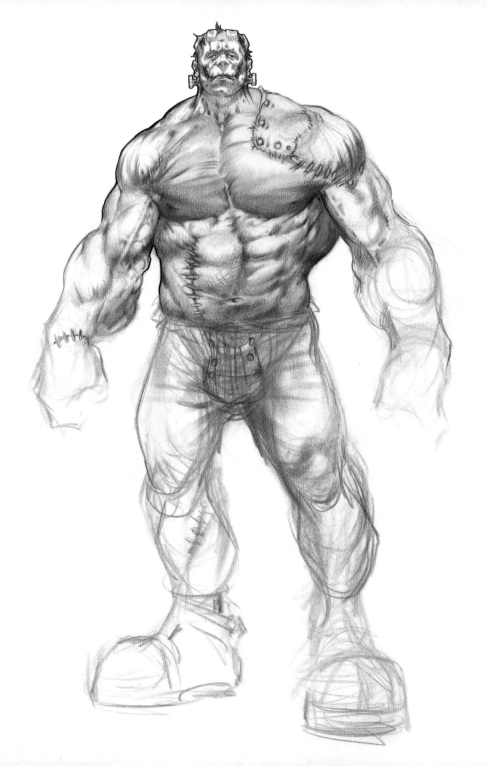

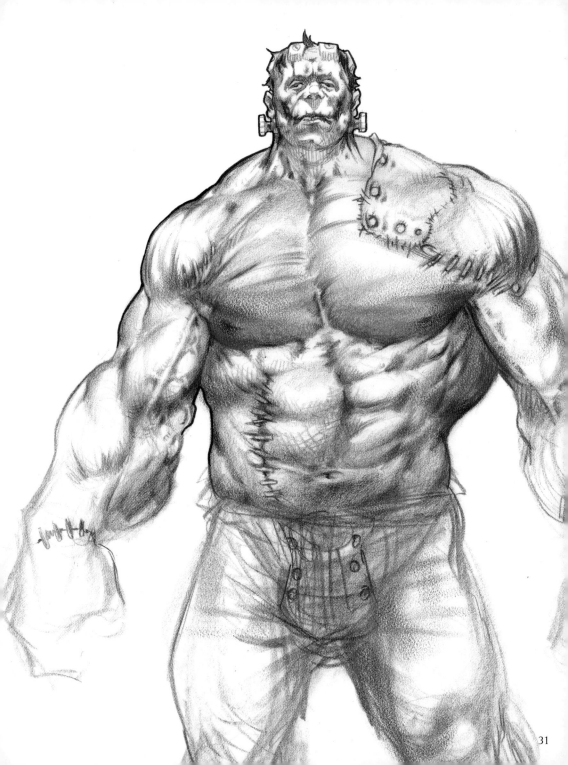

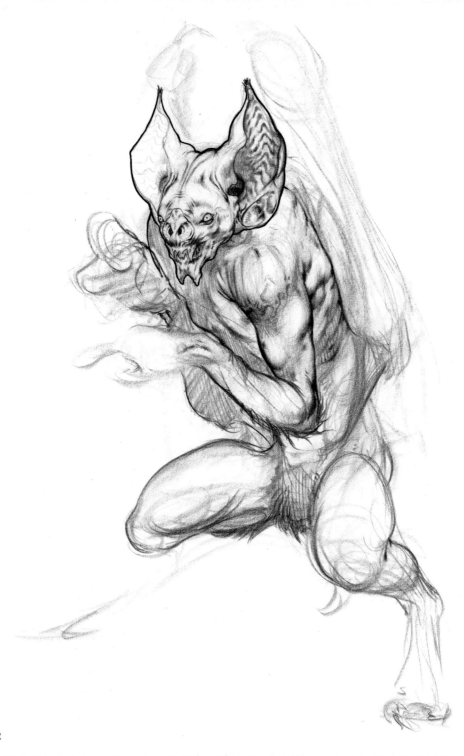

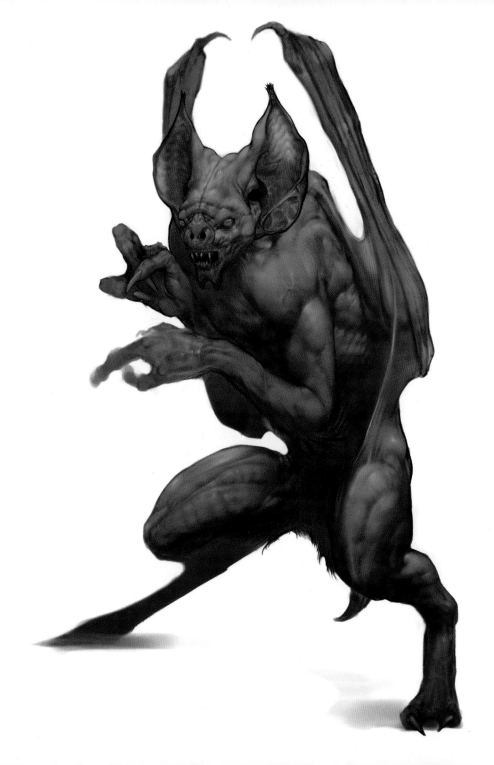

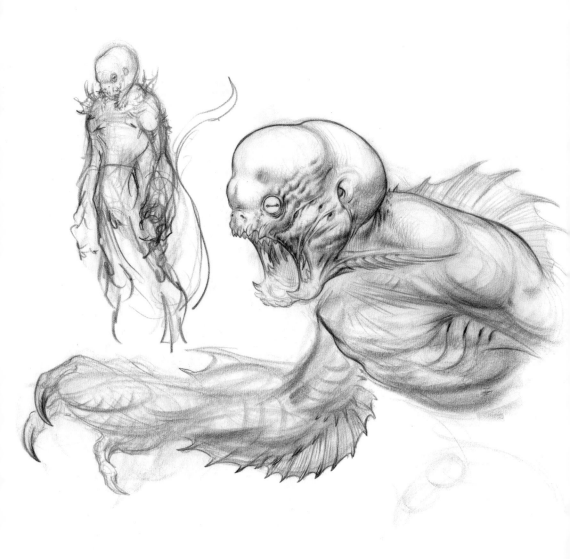

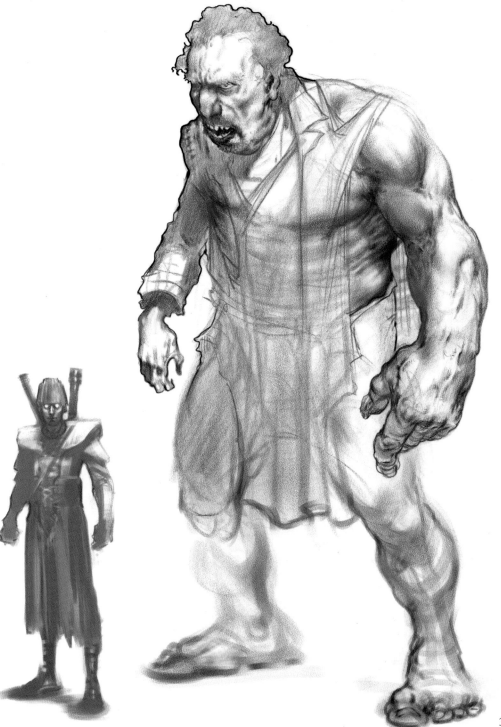

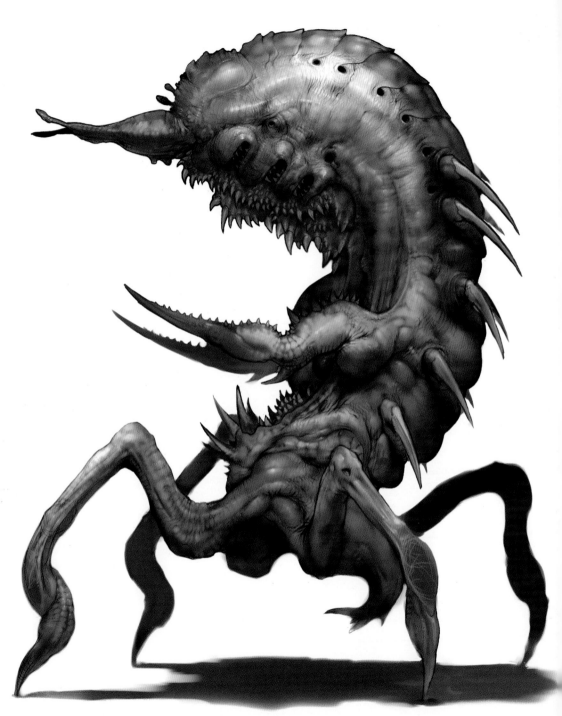

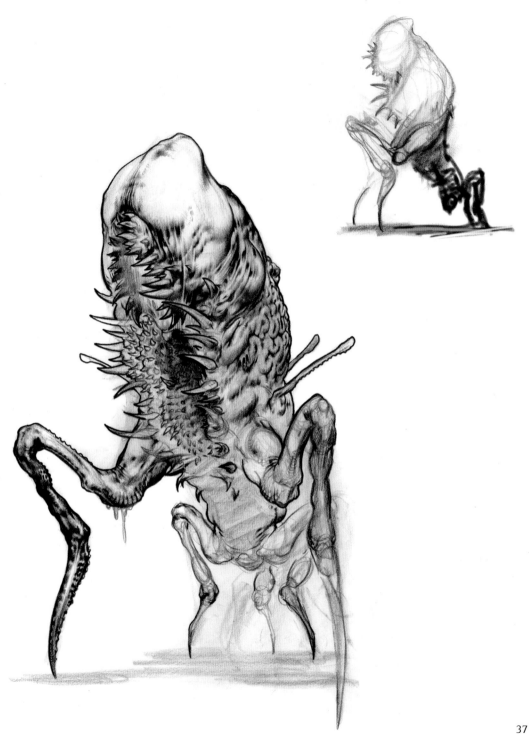

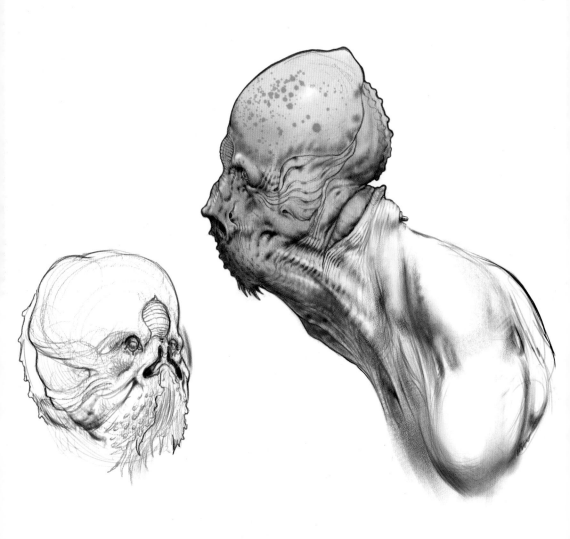

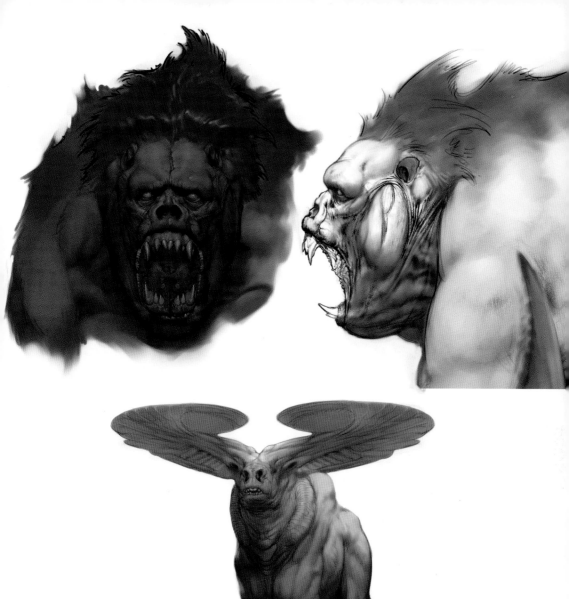

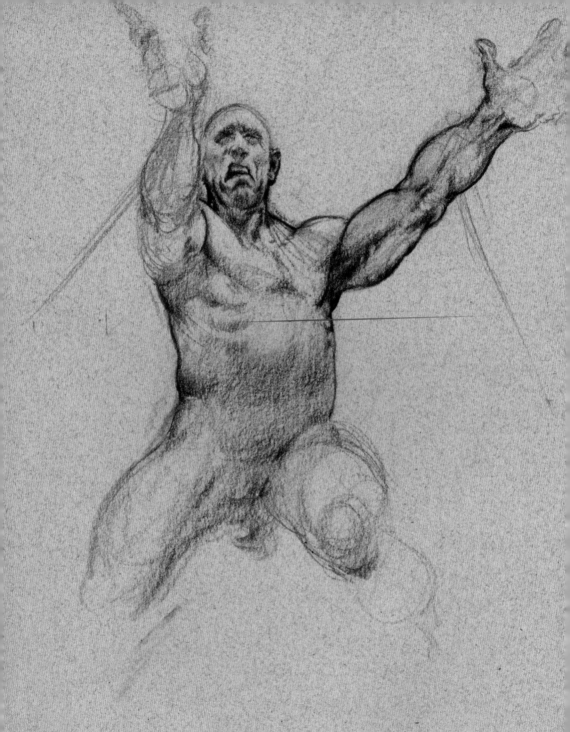

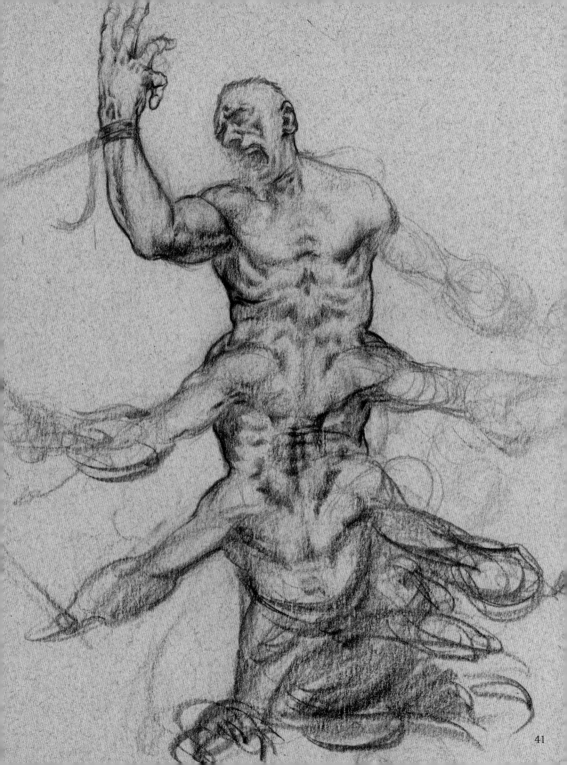

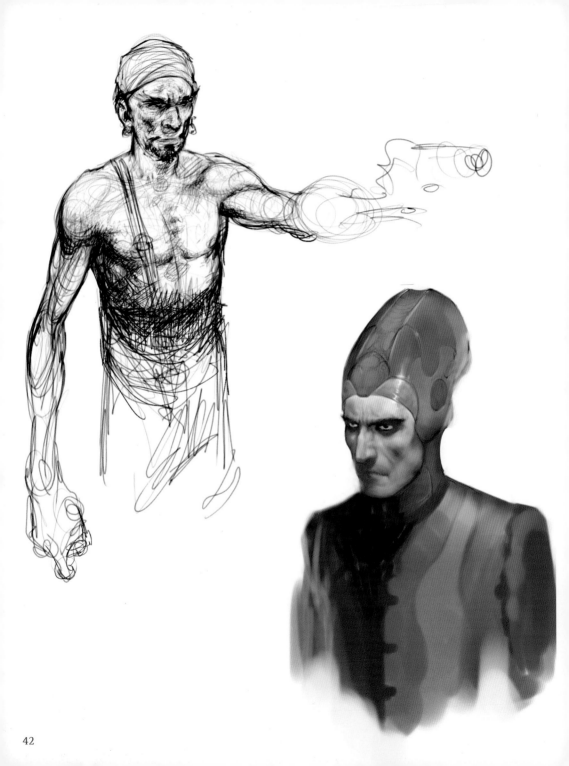

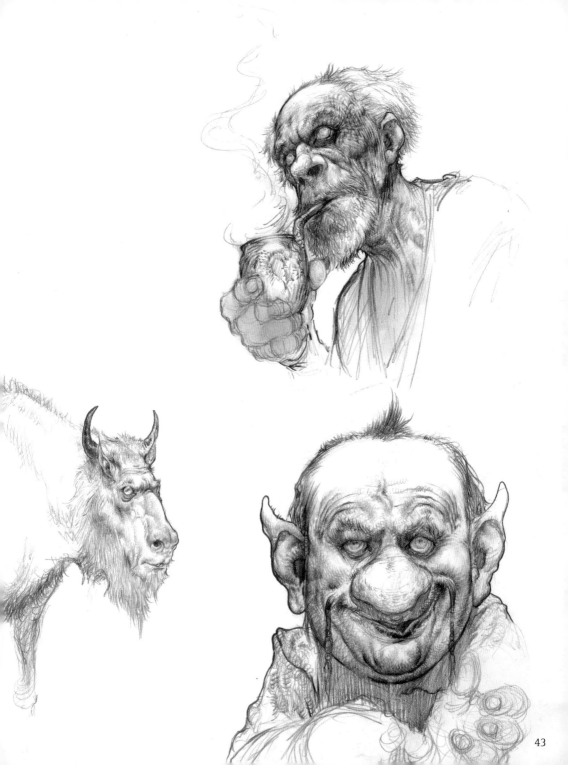

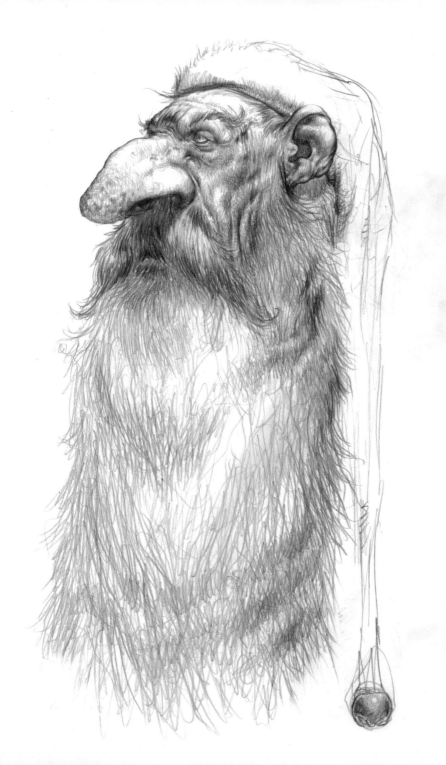

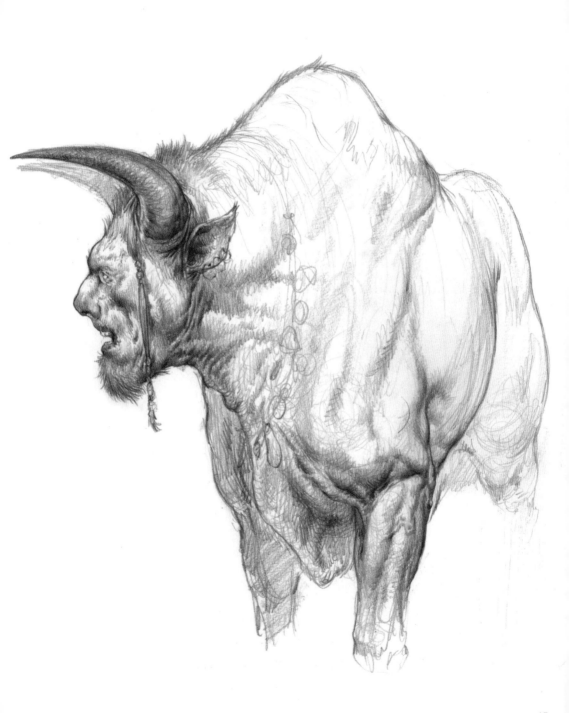

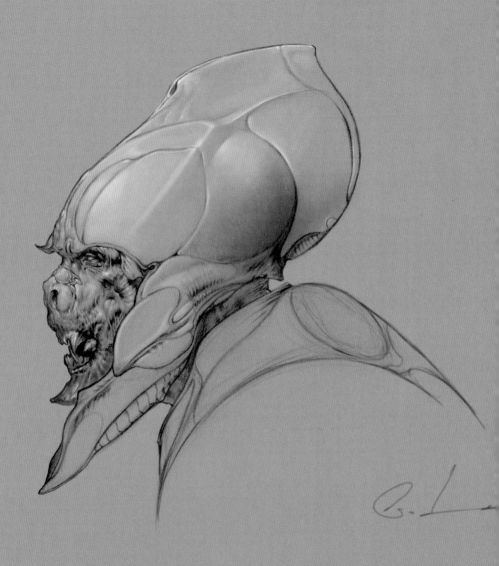

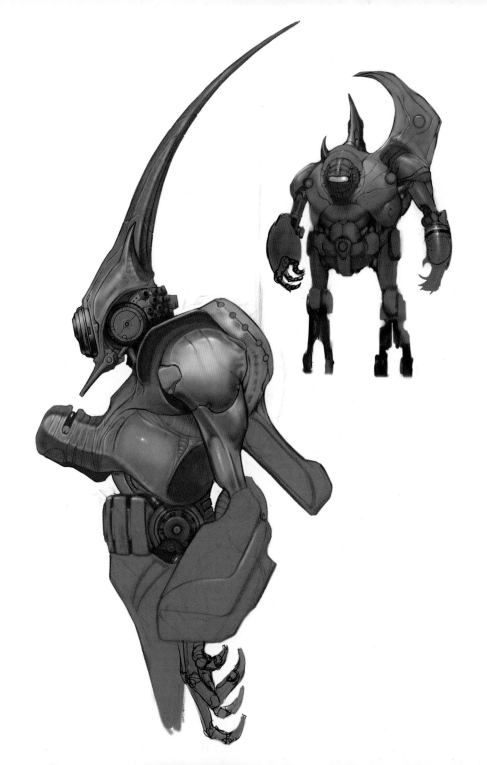

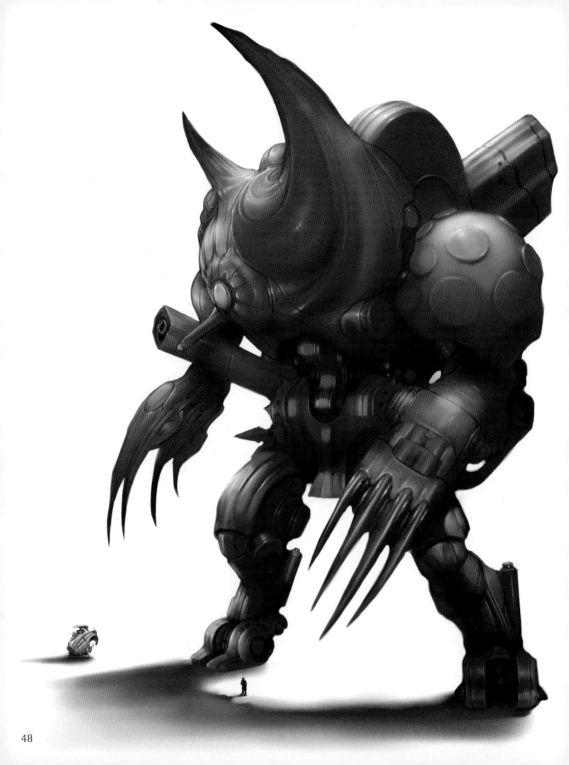

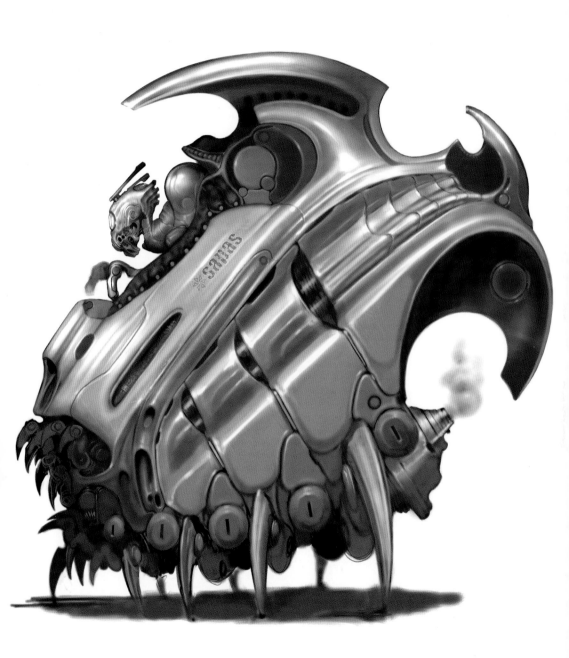

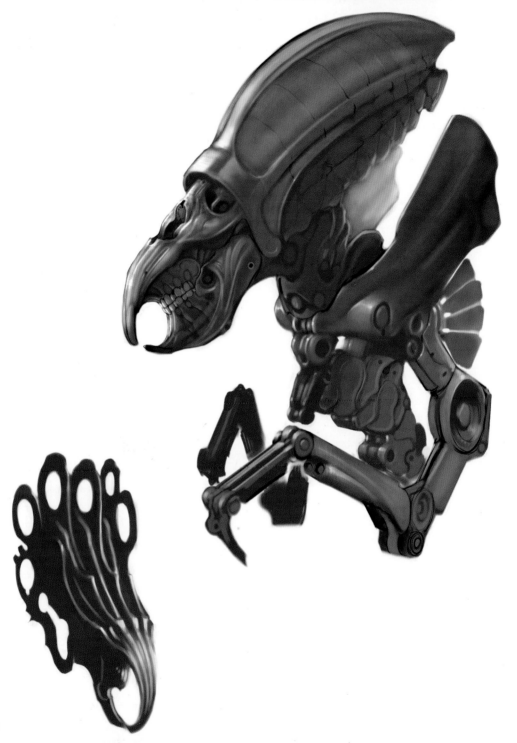

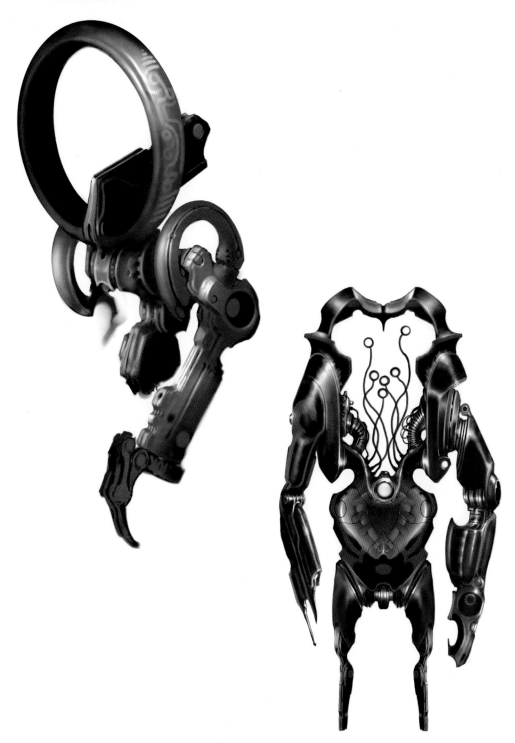

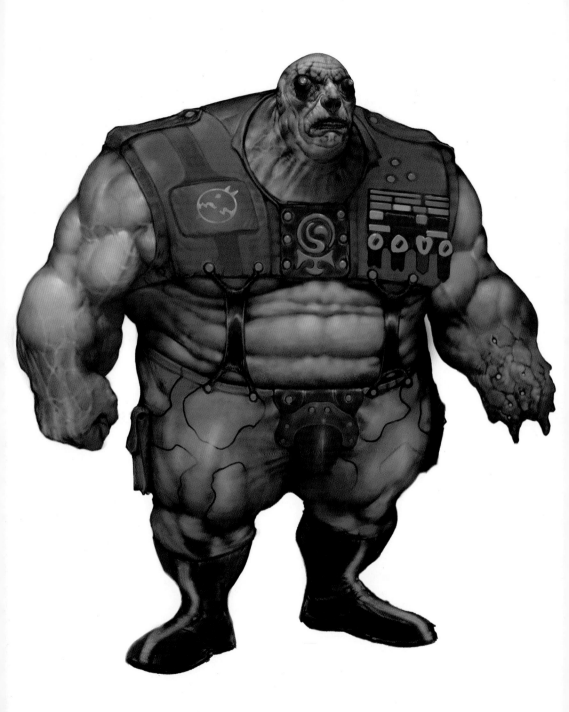

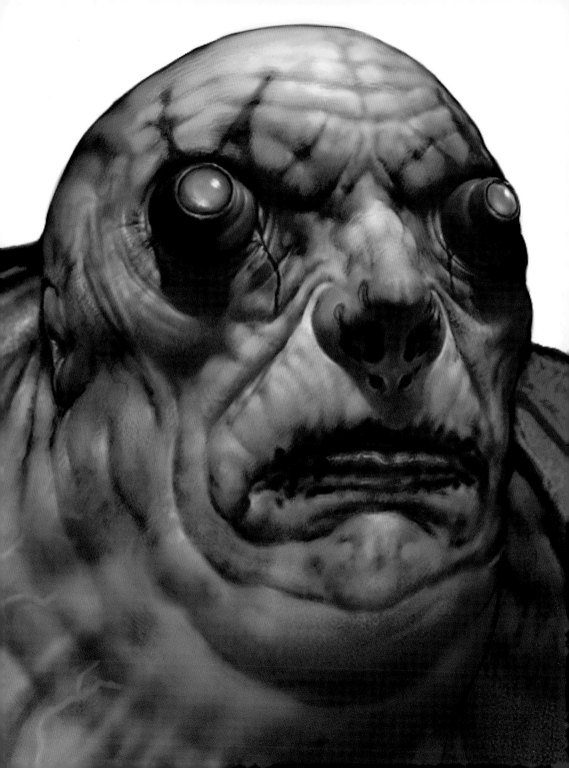

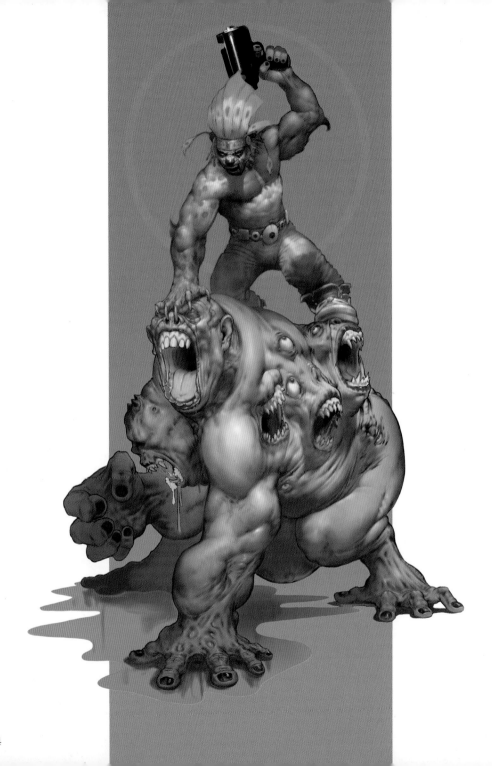

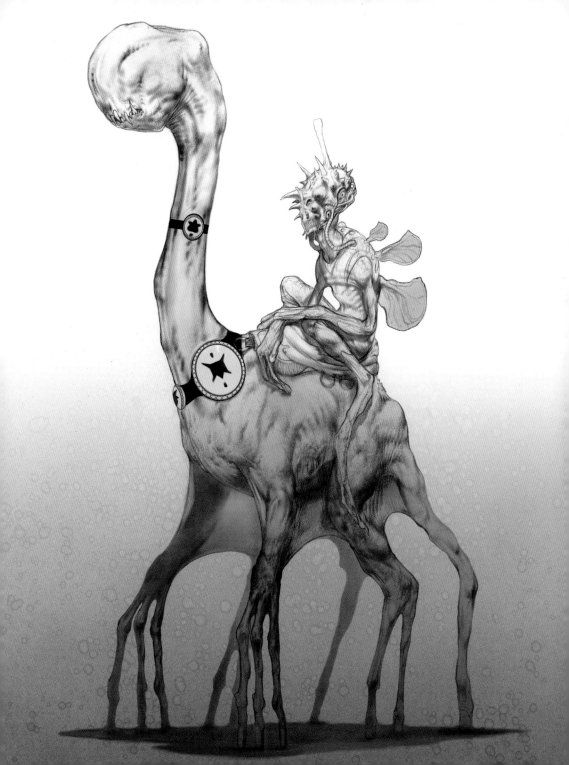

other titles by design studio press:

ISBN 0-9726676-9-5 hardcover

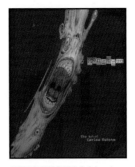

ISBN 0-9726676-3-6 hardcover
ISBN 0-9726676-2-8 paperback

ISBN 0-972-6676-8-7 hardcover
ISBN 0-972-6676-4-4 paperback

ISBN 0-9726676-0-1 paperback

ISBN 0-9726676-7-9 paperback

ISBN 0-9726676-6-0 hardcover
ISBN 0-9726676-5-2 paperback

To order additional copies of this book
and to view other books we offer, please visit:
http://www.designstudiopress.com

For volume purchases and resale inquiries please e-mail:
info@designstudiopress.com

To order copies of the DVDs
and to view other DVDs we offer, please visit:
http://www.thegnomonworkshop.com

Or you can write to:
Design Studio Press
8577 Higuera Street
Culver City, CA 90232

tel 310.836.3116
fax 310.836.1136

Educational DVDs by Carlos Huante:

Creature Sketching
and Design
ISBN 1-930878-71-0

Digital Creature Painting
ISBN 1-930878-72-9

designstudio PRESS